SKETCH LIKE NO ONE IS WATCHING

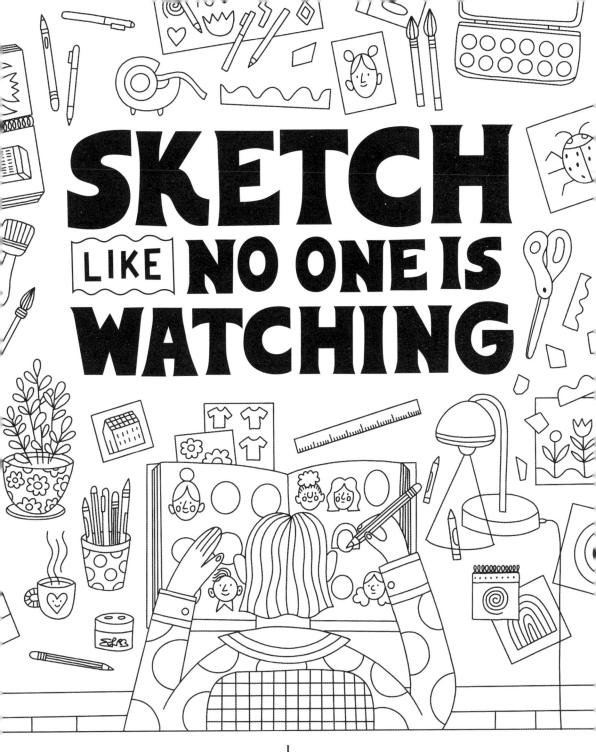

SKETCH LIKE NO ONE IS WATCHING

A BEGINNER'S GUIDE TO CONQUERING THE BLANK PAGE AND DEVELOPING YOUR STYLE

MOLLY EGAN

Contents

Introduction

Hello!

Whether you are an experienced artist or just getting started, making art can be an intimidating thing. In this book, I want to help take the fear of the blank page away and show you how fun drawing can be, even if you make some mistakes along the way. As you move through the book, it's important to see it all as a learning experience. No one's drawings are perfect. I make mistakes all of the time!

When I first graduated from art school, I had to take a day job in an office while I dreamed of being a freelance illustrator. Sketchbooks became the place where I could release everything I was feeling. I used them to experiment, to learn and to find the style I now use as a professional illustrator. A lot of the older pages in those books are nothing like how I would draw now, but it was all part of the journey – just as the way I am drawing now will continue to evolve.

Whether you want to draw as a hobby or make a living with your art, I hope this book helps jump-start your journey with drawing. We'll be drawing all sorts of things, from buildings to people to objects. My main advice is to not be fearful to take risks. Try new media. Boldly start an exercise that seems a little new and intimidating. Experiment with a different style. It's not about being perfect, it's about trying and enjoying yourself.

How to Use This Book

There isn't a wrong way to use this book, but I do suggest going chronologically if that suits your fancy. As you move through the book, the concepts and lessons get a bit more challenging, so building your skills before tackling those pages will be helpful.

When you get to the more difficult sections, I also suggest warming up, especially if it's been a while since you reached for the book. Warming up isn't only for athletes! Just as you would stretch before a big game or a jog around the block, you should warm up your hand and brain before beginning to make art. You can do this by doing a simpler exercise that you missed, doodling in the margins or colouring in one of the black-and-white illustrations I have throughout the book.

Most importantly, try to relax and have fun while you go through the book. If something isn't clicking, that's OK. Come back to it another day with fresh eyes.

Art Kit

Let's Talk Art Supplies

First off, it's really important to note that just because I love these materials doesn't mean they are the "right" materials. These are the things that work well for me, but you might like something else a bit better. Also, just because something is more expensive doesn't automatically mean it will be better or you will like it more. I use a mixture of high- and low-end materials and I prioritise investing in the media that I love and use the most, like paint.

There are a lot of suggestions here about brands that work for me, but please don't get discouraged if they don't end up working for you. I suggest buying one or two colours of the supplies that interest you before investing a lot of money into full sets. It might take some trial and error, but you will find what you enjoy using.

Use this book as a chance to try out materials that you may not have experimented with before. Not every medium will work on the pages of this book, but you can always take the prompts and explore them on heavier paper.

Paint

Holbein acryla gouache is my favourite paint. I have been using it for almost 10 years. Though I've tried many other paints, it's really my tried and true. It has vibrant, opaque colour and a matte finish. This paint has components of acrylic (so does not reconstitute or re-wet) and gouache (matte and opaque), which is a perfect combination for how I like to work. The matte finish also easily allows you to work on top of the painting with coloured pencils or other media.

I'll be honest and say this paint is a bit of an investment. If you are interested in trying it, I suggest picking up a few tubes in your favourite colours to see if you like it before committing to an entire set.

In this book or your sketchbook, any matte acrylic or acrylic gouache will do. Make sure you are not adding too much water to your paint, because the pages of this book aren't designed for super-wet media. Also, I suggest not using paint with a sheen in this book or any sketchbook. Shiny acrylic paints can make your sketchbook pages stick together, especially when it's humid.

In addition to my pricier paints, I also buy inexpensive matte paints intended for crafts at craft stores, which typically sell for about $1.

Paint Brushes

I have used both cheap and expensive brushes; I use brush sets by Blick, but I also like to treat myself to nice brushes by Escoda. They are wonderful, but unfortunately I can't always be trusted to take care of them! Don't be like me. Whenever you are done with an art session, wash out your brushes and do not leave them brush down in a water cup.

I typically paint with round brushes with short handles. They are the most comfortable for me, since I mostly paint rounded shapes. There are many different brush shapes, so I suggest trying them out and seeing what is most comfortable for the way you work.

Paint Pens

Paint pens are what got me back into painting after several years of making mostly digital work. Even though you feel like you are drawing, you produce a painted result! I personally think that's pretty cool. They are also perfect for on-the-go drawing. My favourite ones are made by POSCA.

Coloured Pencils

There are so many coloured pencils out there, and they really vary in quality. My favourite brands are Prismacolor and Derwent; they have vibrant colours and aren't super waxy. Some coloured pencils, especially student-grade ones, can have a lot of wax. Waxier coloured pencils are more difficult to use, so I suggest avoiding student grade coloured pencils when possible.

Pencils

I don't use any fancy pencils. Actually, I still use the same Bic mechanical pencils I used in high school maths class to make my drawings today. I also firmly believe you can never go wrong with a Dixon Ticonderoga, if you prefer to go the non-mechanical route.

Gel Pens

I was born in the early '90s, so of course I love a gel pen. My favourite brand is Gelly Roll. They have many different colours and all of them are opaque. They are another great option for on-the-go sketchbooking.

Markers

Tombow markers are great and also quite affordable. I love sketching with them. They will likely bleed through the paper in this book, so if you are in the mood to work with markers, draw on separate paper and then glue or tape your drawing in!

Scrap Paper

I keep a big drawer of scrap paper in my studio. There are loads of uses for it, and I try my best to not let things go to waste! It's a great way to cover up mistakes in a more creative and pleasing way. You can use it to create cut paper collages or to cover drawings you aren't particularly fond of. If there is a medium that doesn't work particularly well in the pages of this book, like marker or watercolour, you can use them on separate paper then glue or tape it in the book. I also always put a piece of scrap paper behind the page I'm drawing/painting on; it prevents any transfer of pencil or paint from your current or previous spreads.

Clips

Clips are great when you are working on, or photographing, a page. If you have bulldog clips those are perfect, but if you only have bobby pins (hair grips) in your house, those work too!

Sketchbooks

Moleskines are my go-to sketchbook that I have used for years. They happily accept acryla gouache and most other media. I typically have one of their small and large art sketchbooks going at the same time. They also have sketchbooks specifically created for watercolours!

Test Pages

Use these pages to test your materials.

"Fun Things to Draw" List

A huge part of finding your style is knowing what you are inspired by and what you like to draw. I'm a list-maker in general, but I think it's particularly helpful to have a list of things you truly love drawing. There are times when we all get stuck and uninspired, and looking back at your list can spark an idea!

Here's my list! It's things I draw a lot, things I look to for inspiration and things I want to draw more of.

1. ladies
2. birds
3. flowers
4. patterns
5. earrings
6. ornate furniture
7. big glasses
8. moths
9. dogs
10. berets
11. floral hair
12. antique quilts
13. cottages
14. retro doors
15. plants
16. cats
17. hairdos
18. vintage tiled bathrooms
19. checkerboard
20. figure drawing
21. trees
22. bell bottoms
23. applique on quilts
24. vegetables
25. trees
26. Victorian homes
27. fuzzy coats
28. maximalist rooms
29. manicures
30. botancial illustration
31. vintage sewing patterns
32. travel posters
33. leaves
34. fuzzy coats
35. Pyrex dishes
36. mid-century furniture
37. antique pottery
38. colourful makeup
39. folk art
40. poofy dresses
41. landscapes
42. butterflies
43. strawberries
44. bouquets
45. basset hounds
46. chickens
47. striped hair
48. rainbows
49. gap teeth
50. royal garb

Now make your list. You don't have to do this all in one sitting. I actually suggest writing a few down now and continuing to think about it as you work through the book.

1. _____	26. _____
2. _____	27. _____
3. _____	28. _____
4. _____	29. _____
5. _____	30. _____
6. _____	31. _____
7. _____	32. _____
8. _____	33. _____
9. _____	34. _____
10. _____	35. _____
11. _____	36. _____
12. _____	37. _____
13. _____	38. _____
14. _____	39. _____
15. _____	40. _____
16. _____	41. _____
17. _____	42. _____
18. _____	43. _____
19. _____	44. _____
20. _____	45. _____
21. _____	46. _____
22. _____	47. _____
23. _____	48. _____
24. _____	49. _____
25. _____	50. _____

Step by Step

Let's draw a portrait together!

Start with a curved v.
Think of drawing a bird
in the sky.

Next, draw a
curved line that
connects the v.

Add an ear to both
sides of the head.

Draw another curved line
from ear to ear.

Add a big circle
on top of her head.

Give her a nose.
Put the bottom of the nose
at the center of the ears.

Add eyes, a mouth and
some detail to the ears
and cheeks.

Put in some more final
details. Add whatever
patterns you'd like.

Finally, add some colour.
I used gel pens and
coloured pencils.

Now it's your turn! Draw your own version(s) of this portrait below. Feel free to experiment with your own patterns and colours, and don't worry about getting it exact.

Colour all these friendly faces.

Draw your own face here! Try recreating one of the people I drew on the left. Don't forget to add plenty of pattern and colour to give your face lots of personality.

Give the people faces.

Give the hair some faces to match.

Add a face to this hair. You can also create a background and the top they are wearing.

Let's give this person a face.

Step by Step

Start with a circle.

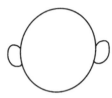

Next, draw two ears.

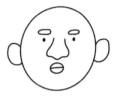

Add the face.

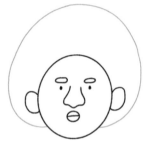

Now add a curved guide line for the hair.

Add a scalloped edge along the guide line.

Erase the guide line.

Draw some small lines for a stubbly beard.

Add in some details to the hair!

Finally, add some colour. I used gel pens and coloured pencils.

Now it's your turn! Draw your own version(s) of this portrait below. Remember, my drawing is just a guide. Try any patterns or colours that fit your style.

Complete the people. Who would wear these sunglasses?

Turn these circles into people. Instead of just adding faces and hair, also think about glasses, freckles, piercings, facial hair and more.

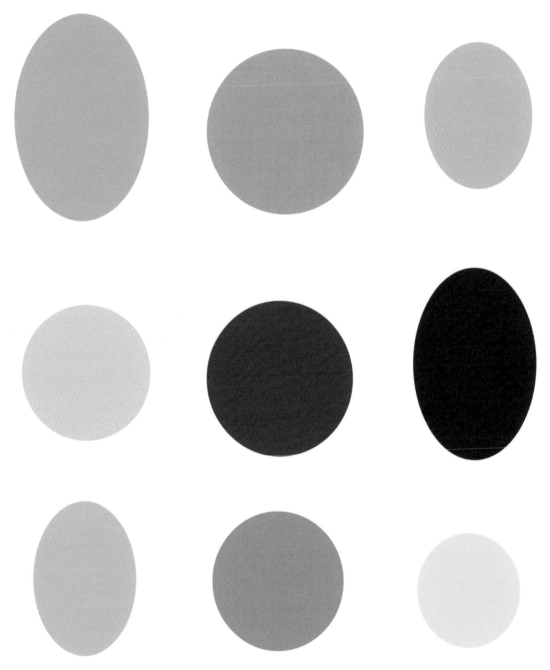

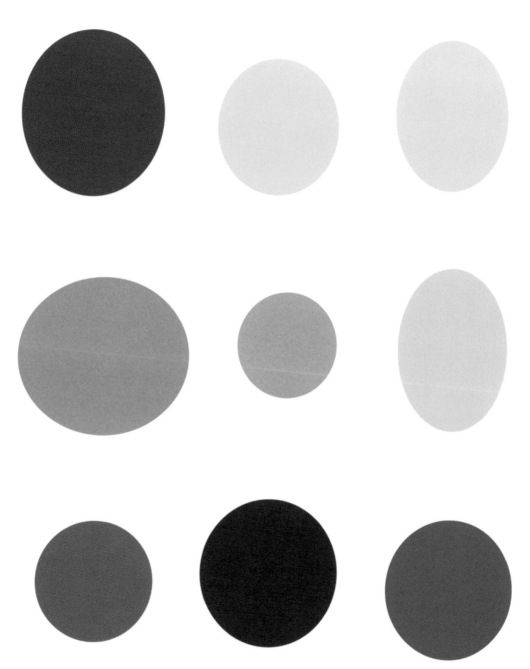

Fill these pages with portraits from your own imagination.

Blind contours are a great exercise for warming up, improving hand-eye coordination and making silly drawings that will make you laugh.

All About Blind Contour Drawings

It's so important for artists at any skill level to loosen up and try different ways of drawing. I personally think that blind contours are a perfect way to loosen up, free any inhibitions and play. While you are having fun drawing, you are also improving your coordination and observation skills. It's so cool to see how you improve as you continue to practice!

When making a blind contour drawing, you do not look down at the page or lift your drawing utensil at all. Instead, you put all of your focus on intently looking at the subject you are drawing. Blind contours help train the eye to draw what it really sees.

Blind contour drawings are just a no-pressure warm-up exercise, so please try to resist the urge to look at your paper. I know it can be really tempting! I promise these drawings aren't meant to be perfect, so have fun with it. Often times, you will make a drawing that looks a bit silly, but that is honestly my favourite part. Try to relax, draw every detail you see and not look at the page. Simply enjoy the process, regardless of the result.

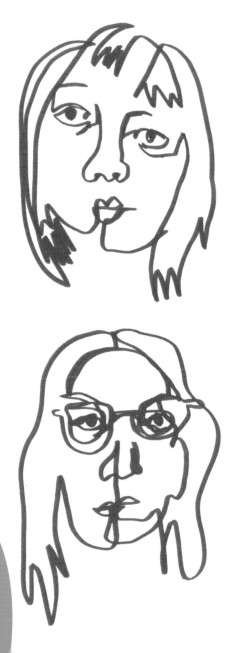

Try your first blind contour! Now that you know what a blind contour is, give your first one a go. I suggest doing a self portrait first. Sit in front of the mirror with your book and drawing utensil. Look at yourself closely. Try to draw every detail you see. Do you have long eyelashes? Are you wearing earrings? A hat? Capture as much as you can and go slooooowly.

Draw some of your favourite plants in blind contour. You can do this from life or a photo. Don't worry if they overlap, that's part of the fun.

Do a blind contour of a piece of furniture in your home.

Do blind contours of your non-dominant hand in different poses all over this page. If you are wearing jewellery or have any tattoos, be sure to include those in your drawings too.

Draw portraits in blind contour. You can draw these from life or from photos.

Lesson:

COLOUR THEORY BASICS

It can be tough to pick the right colours for our precious drawings. Let's learn some fundamental colour theory to elevate your drawings and paintings.

This is the colour wheel. There are twelve colours that are on the colour wheel. Three **primary colours** (yellow, red, blue), three **secondary colours** (orange, violet, green) and six **tertiary colours** (yellow-orange, red-orange, red-violet, blue-violet, blue-green and yellow-green).

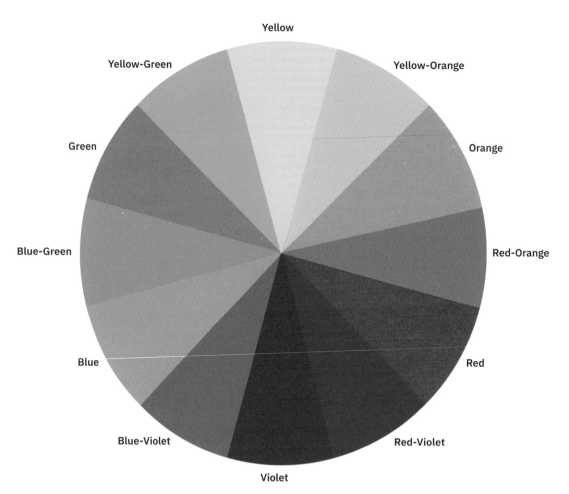

Keep in mind while creating your own palettes that these colours don't have to stay at their most vibrant; you can also **tone** (desaturate), **tint** (lighten) and **shade** (darken) them.

Let's go over some common ways to use the colour wheel to create dynamic, interesting colour schemes. Once you learn and apply these, you'll be surprised how picking colours becomes quite natural.

Monochromatic

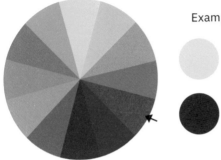

Example colour palette

Monochrome translates to "one colour", but there's much more to it than that. For a monochomatic colour scheme, you pick one hue – say, red – then use all of the tones, tints and shades of that colour.

Colour this house with monochromatic colours.

Analogous

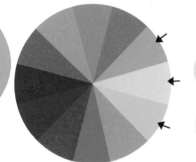

Example colour palette

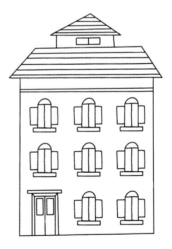

Analogous colour schemes are a great way to build a harmonious palette. They are made by choosing three colours (these can be tones, tints and shades) next to each other on the colour wheel.

Colour this house with analogous colours.

Complementary

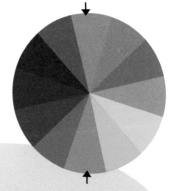

Example colour palette

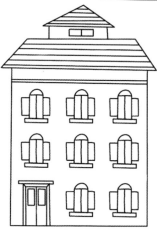

Complementary colours are directly opposite each other on the colour wheel. I love to use complementary colour schemes in my work. Instead of using them at their most intense, I often darken/lighten the shades of the complementary colours. You can also mix colour opposites together to make vibrant browns.

Colour this house with complementary colours.

Split-Complementary

Example colour palette

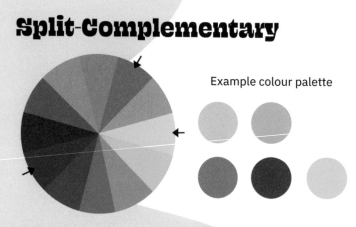

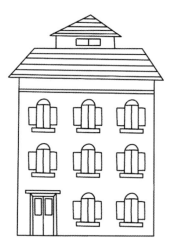

Split-complementary colour schemes are pretty similar to complementary colour schemes; they just have a little twist. You can make a split-complementary scheme by taking a colour on the wheel, looking directly across to the complement, then using the colours on either side of that complement.

Colour this house with split-complementary colours.

Colour choice can really help evoke a mood in your piece. Use the prompts to guide your colour choices for these houses. You can also use the colour schemes you learned here.

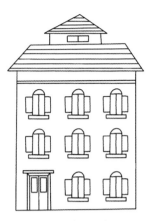

A cool, spring morning.

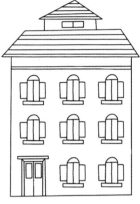

A haunted house.

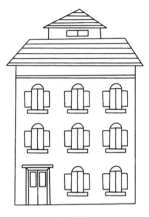

A playful home.

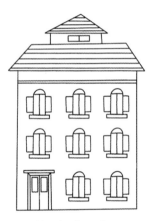

A luxurious brownstone.

A warm, summer day.

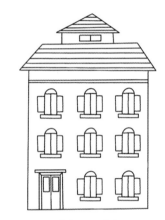

A starry evening.

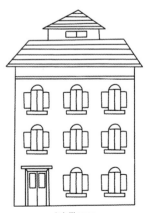

A dollhouse.

A stormy night.

A crisp, autumn morning.

Colour the people and their furry friends.

Colour and add designs to these clothes. Are they all different or part of a collection?

Add some pattern and colour to the happy cats.

Give these people colourful, pattern-filled outfits.

Design the dogs with colour and patterns. Also, think about adding some flowers and plants to the background to make it feel like a park.

Add pattern to the ladies' clothing. Try polka dots, florals or stripes in all different colours.

Add feathers, colours and patterns to this bird.

Design all the insects.

Step by Step

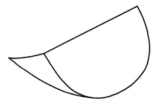
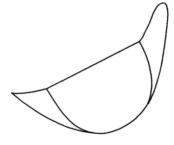

Draw a wide U shape and then connect the points with a straight line.

Add two curved lines to create tail feathers.

Now, draw the head and neck of the bird.

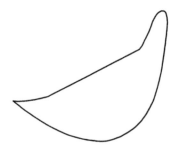

Erase the guide lines.

Draw a teardrop shape for the bird's wing.

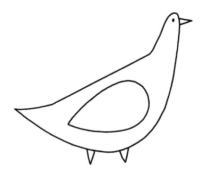
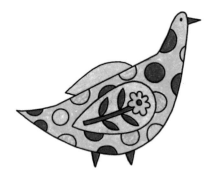

Add an eye and draw triangles for the beak and feet of the bird.

Finally, add details and colour! I used coloured pencils.

Now it's your turn. Draw your own version(s) of this bird below. Think about things you can change to make it your own too. Maybe a feather on top of the bird's head or a different pattern on its body.

Colour and finish the face.

Draw a self portrait with your new knowledge of colour. Instead of making everything a natural colour, think about how you can use colour to reflect your current mood.

Use your favourite colours to draw a portrait here.

Now, use some colours you don't typically reach for to create another portrait. I think it's super important to push to try new things – sometimes you end up liking them more!

Draw a circle then draw
a smaller circle inside.

Create your first petal.
Think of it as a
"U" shape.

Draw the rest of the
petals. I like having
them overlap.

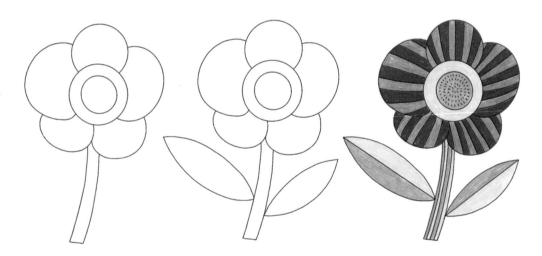

Make the stem. Draw two
lines down from the petals
and connect them.

Draw two leaves. I find
it easiest to start
at the stem.

Finally, add some
details and colour.
I used coloured
pencils here.

Now it's your turn. Try drawing your own version(s) of this flower below. If you need a little practice, trace over my drawings first. Your style will really shine when you add your own details and colour palettes, so try experimenting a bit too.

Add flowers or berries to the stems to complete the pattern.

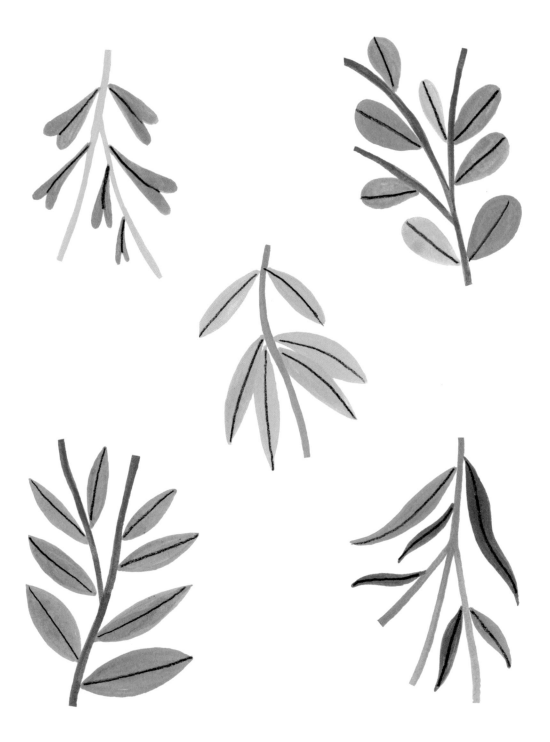

Fill the shelves and add pictures to the frames. You can also add wallpaper to the room.

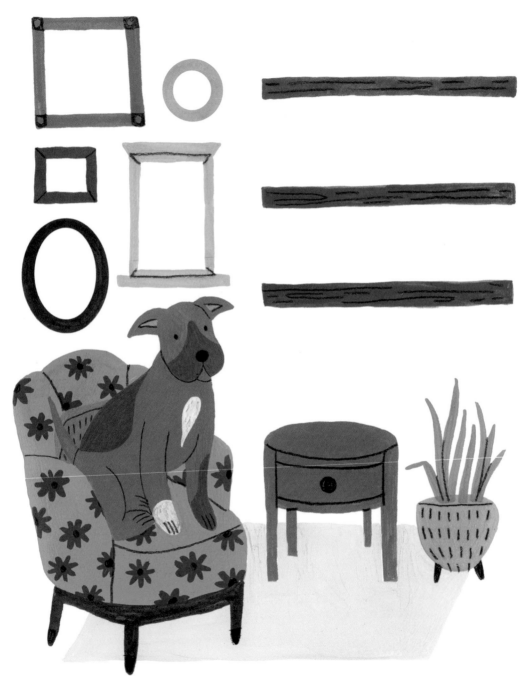

Give the planters some plant friends.

Give some personality to these teapots.

Pull up a chair, sit in front of one of your windows and draw what you see. If you don't have a great view from your windows, make one up!

Add windows, doors and colour to the houses. Feel free to also add more chimneys, sidewalks and plants to make it feel more like a neighbourhood.

Fill these vases with beautiful bouquets.

Add plants to the window box and pots.

Create patterns for the curtains, wall and floor. You can also add the view outside the window.

Step by Step

Start with three lines. The
one of the left should be
slightly higher but the
same length.

Next, connect the two
lines on the left. They will
be diagonal lines.

Now connect
the other line.

Create a triangle at the
midpoint of the two lines.

Create another diagonal on
the far line. It should match
the parallel roof line.

Draw a final line to
connect the whole house
and erase the guide line.

Add simple windows of
whichever shape you'd
like. I used rectangles.

Add in a door. See how the
door follows the diagonal
of the line below?

Finally, add some colour
and details. I used gel pens
and coloured pencils.

Now it's your turn. Draw your own version(s) of the house below. Try your own colours and ideas in some versions. Don't worry about drawing it exactly.

Fill the apartment windows with characters and decor.

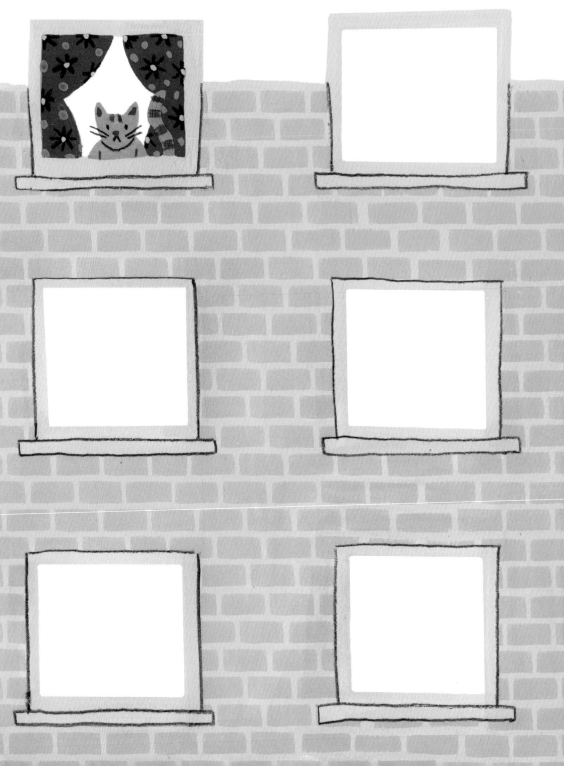

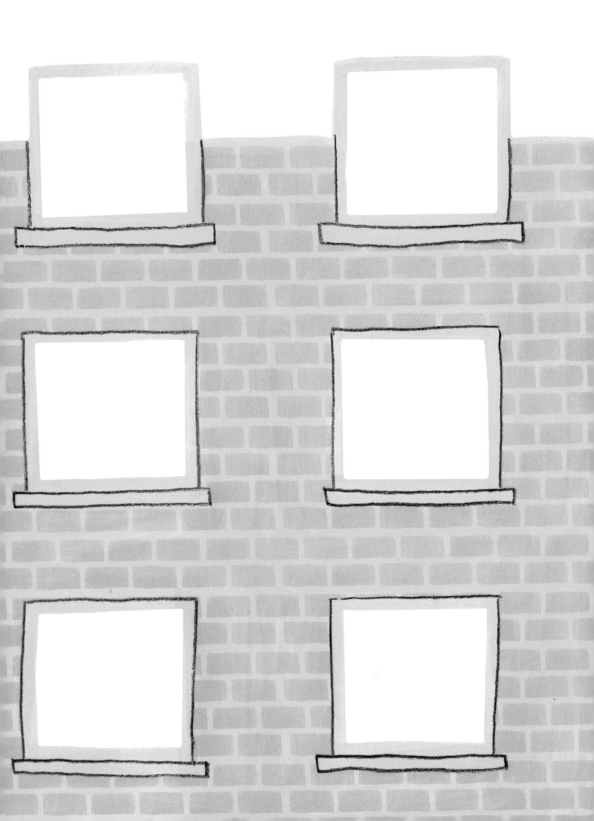

Add doors and windows to these buildings.

Add images to the picture frames.

Add wallpaper and flooring behind this chair. You could also add perspective, people, wall art or a pet. Use your imagination.

Fill this bowl with fish or other creatures.

Colour this scene.

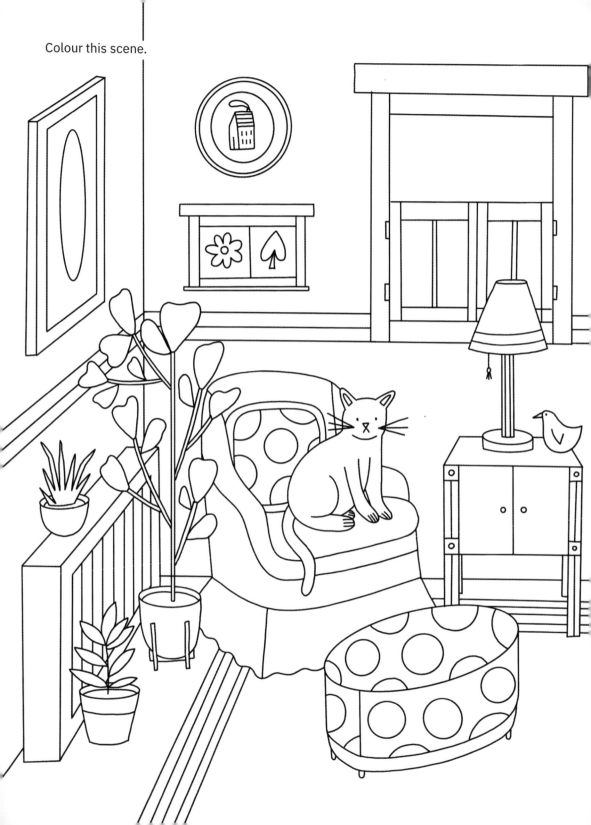

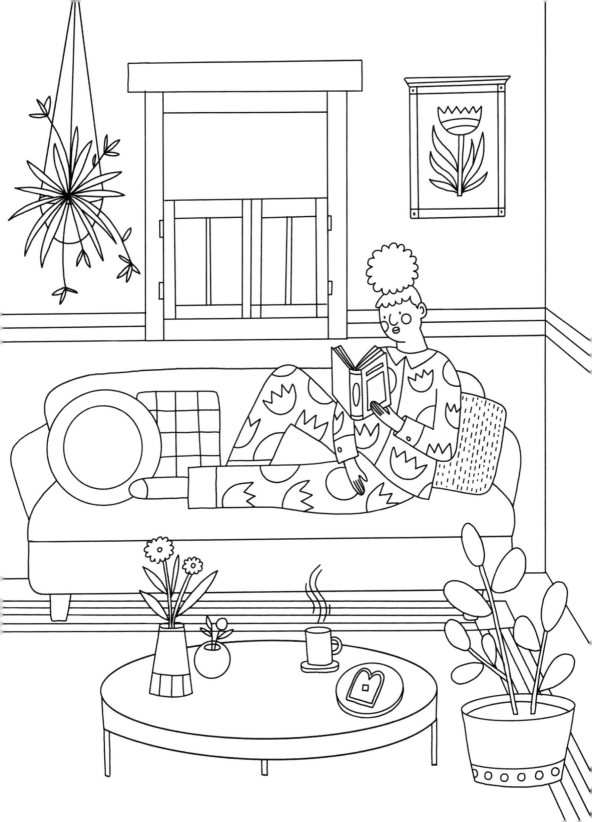

Learning how to draw in perspective is so helpful for a multitude of subjects. It's great for landscapes, interiors, buildings and even still life drawing!

What is Perspective?

Perspective is a drawing technique that helps a two-dimensional surface (like your piece of paper) have the illusion of being three-dimensional or appearing like it has depth.

Perspective can be a fairly challenging thing to learn. For me, it always felt like the math of drawing. Though I don't always draw all of the guides anymore, my knowledge of the rules of perspective informs the more intuitive approach to drawing that I use now.

Important Terms

Viewpoint

In perspective, a viewpoint is where you are viewing the scene. You can play around with this to achieve different finished products. For example, you could do a normal (or eye-level) viewpoint, a low viewpoint (as if you were kneeling), or a high viewpoint (as if you were on a balcony).

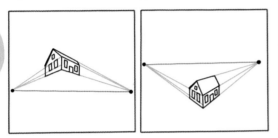

Horizon line

A horizon line isn't always the line where sky and land meet. Instead, try to think of it as your eye-level line. The horizon line is a pair with your viewpoint: if you crouch down, your horizon line or eye level moves down. If you are on a ladder, your horizon line moves up.

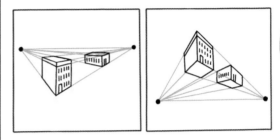

Vanishing point

A vanishing point is a point on your horizon line. You will use this point (or points) as a guide to draw parallel lines, which creates a sense of depth in your piece. All of these parallel lines will meet at the vanishing point(s) on your horizon line.

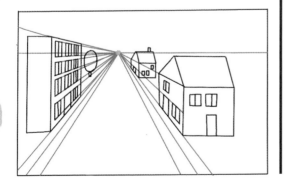

Vanishing line

Vanishing lines are guides drawn to your vanishing point. The angles of your vanishing lines will change depending on where your horizon line is. If the house you are drawing is below the horizon line, the lines of the house will angle up. If the house is above the horizon line and up in a mountain, the lines of the house will slope down.

Linear Perspective

One-point perspective

One-point perspective is the best place to start learning. Picture yourself standing in the middle of a road. That road goes all the way back and meets the horizon at one point (your vanishing point). All trees, buildings, cars, etc. along that one road will use vanishing lines that meet at the same point on your horizon line. I also frequently use one-point perspective when I am drawing interiors.

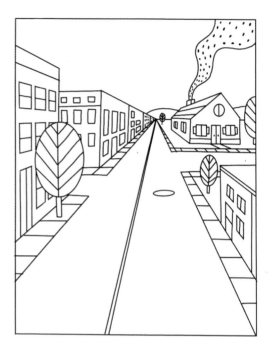

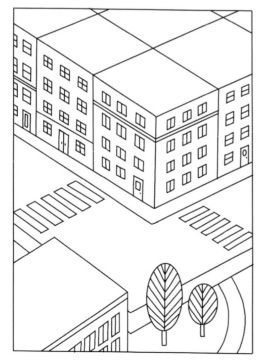

Two-point perspective

Two-point perspective is very similar to one-point perspective, you just add a point! This time, picture yourself at a city corner. A row of buildings converge to the left (first vanishing point) and another row of buildings converge to the right (second vanishing point).

Atmospheric Perspective

Let's move on to a slightly different kind of perspective. Atmospheric, or aerial, perspective shows depth by using colour and detail. This will mainly be used when you are painting or drawing landscapes.

Let's use a landscape as an example. If you are looking at a landscape covered in trees, the trees closest to you will be the darkest, most vibrant, and most detailed. As the trees go further back, they will get lighter, be less colourful (desaturated) and less detailed. This is because of smog in the atmosphere.

In addition to the colour and detail of an object changing, the size of the object will also change. Even if two trees are the same size, one further back should be drawn smaller than one close to you.

This doesn't just apply for trees, but for people, flowers, hills, power-lines and houses as well.

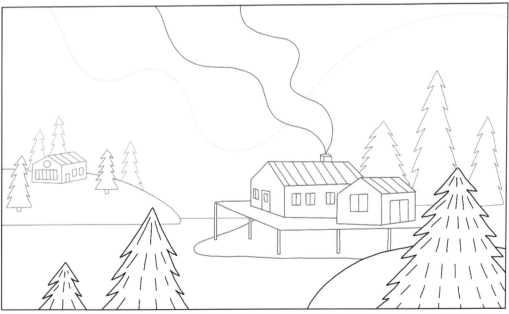

Turn these cubes into buildings using perspective.

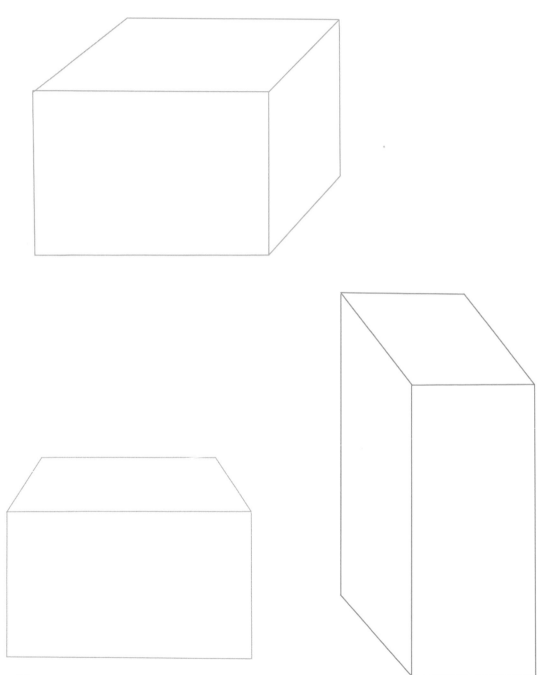

Add colour and designs to these household objects. Make sure to match the angles!

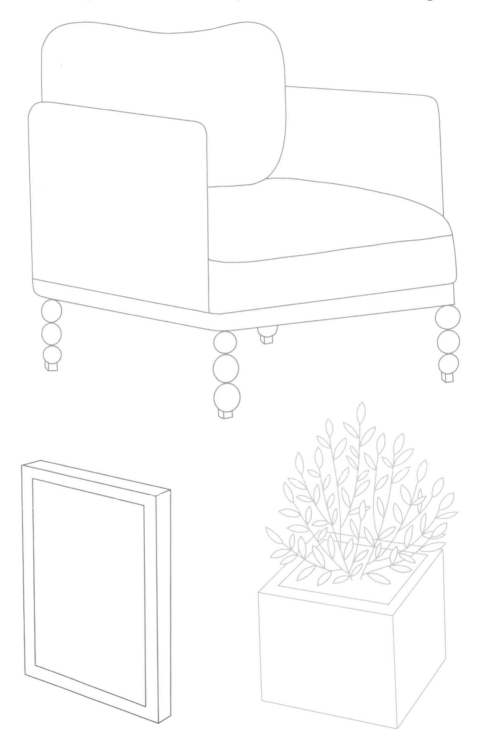

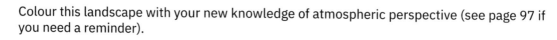

Colour this landscape with your new knowledge of atmospheric perspective (see page 97 if you need a reminder).

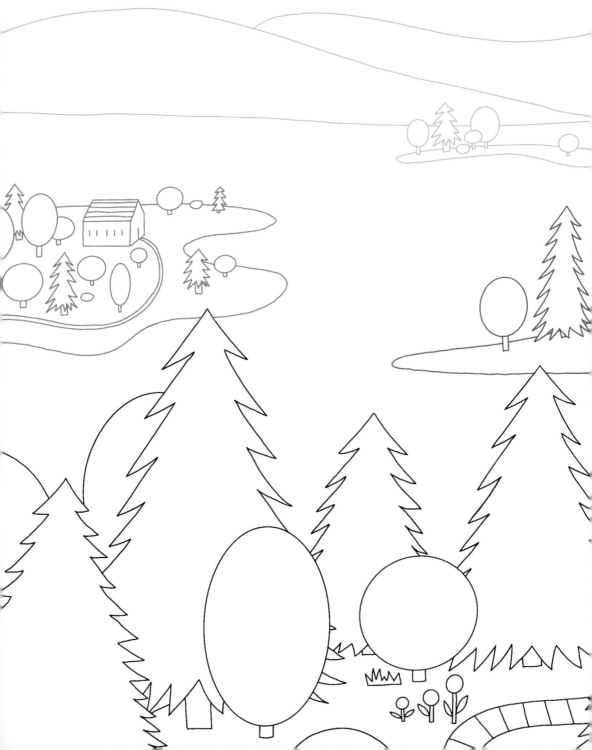

Draw your own landscape showing atmospheric perspective here (see page 97 if you need a reminder).

Add furniture and other objects to this room using one-point perspective (see page 96 if you need a reminder).

Design a cityscape using two-point perspective (see page 96 if you need a reminder).

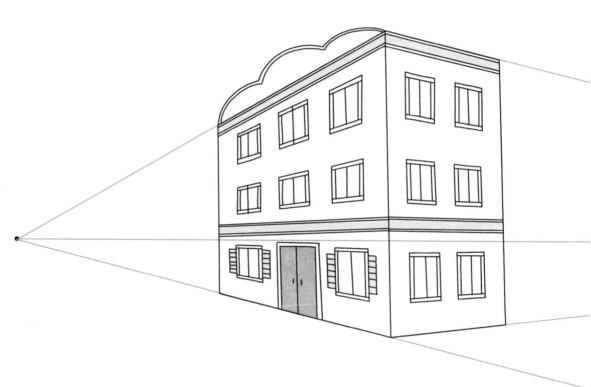

Lesson:
CORRECTING MISTAKES

Making mistakes is part of learning and happens to everyone (including the pros)! Let's talk about making tweaks to an "oops" in your work.

Paper

Mistakes totally happen. They still happen to me all of the time! Instead of ripping a page out of the book, I have a few tricks on giving a mistake a new life. Using paper is one of my favourite ways to cover up things that I'm unhappy with in my sketchbooks.

Post-Its are one option that work great for covering up undesirable drawings and doodles. I typically use a few, since Post-Its themselves are a bit transparent. I also add a small piece of tape or use a glue stick to make sure it stays down.

Any sort of scrap paper also works perfectly for this. In the second example on this page, you'll see that I used some patterned paper. It was actually a bit of wrapping paper I had a scrap of! I always like to keep scraps of paper for this exact purpose.

I love using paper, because it can make covering mistakes look purposeful. Even if I'm covering a drawing in one area, I try to use the paper in multiple spots, which makes it appear like an intentional collage, rather than an obvious mistake-covering device.

Paint

If I make a mistake in my painted sketchbooks, I cover it with more paint! It might sound somewhat obvious to cover paint with paint, but it really creates a blank slate.

I'll cover the whole page I'm not so fond of in a solid dark colour; it doesn't always have to be straight black either. You can do navy, dark green, dark purple or whatever you have in mind! Dark colours are best, because it's much easier to cover your previous work.

It can be a bit challenging to put very light colours on top of the new, dark background colour. If you are going that route, I recommend doing a layer of paint pen before putting paint on top. Also, you can paint on paper and then collage it into your book and combine both of these covering ideas!

Move On

Moving on is probably the hardest option. Making a drawing you don't like can be frustrating, especially if you are starting as a new hobby. I suggest taking a breath and closing this book (or your sketchbook) before ripping out any pages. The next time you open it up, you might realise that it's not really that bad or think of a really creative way to reinvent it!

Draw all over these pages and don't erase! If you make a mistake, no problem. Try covering it with scrap paper, paint or draw the correct line next to your mistake.

Let's try drawing all over these pages without an eraser again. If you make a mistake, cover it with scrap paper, paint or draw the correct line next to the mistake.

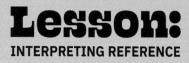

Lesson:
INTERPRETING REFERENCE

Reference imagery is such an important tool for artists. Whether you are sourcing your reference online or shooting your own, it's important to interpret it through your own lens and style.

Let's first talk about how to pick a successful reference photo. I like to pick images that have a lot of colour and distinct things for me to draw. In this case, I know I will enjoy drawing the pink hair, large glasses and full eyebrows.

There are so many ways you can alter what you see in the photo in your drawing. You could make her hair much larger; make her glasses much smaller; change the colours; stretch, pull and widen features of her face; add accessories; and much more. I'm going to talk you through some examples of what I did to make this reference photo my own.

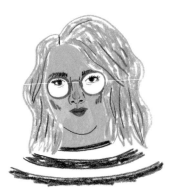

For this one, I highly stylised everything and broke all of the features down into basic, geometric shapes. I also changed some facial proportions and made her face significantly longer. Lastly, I added a floral pattern in her hair and changed the stripes of her sweater to a dash pattern.

This portrait is truest to the original photograph. It is a little more realistic and less stylised. I also tried to be a bit looser with this one, enjoying mark-making with coloured pencil. Though this portrait isn't photo realistic, it's much more rooted in realism than the other examples.

Finally, I did one more cartoon-y, stylised interpretation of the photo. I really exaggerated the eyes, because I wanted them to be the focus, then I made the other features of the face quite small. I also made her hair shorter, changed the shape of the glasses and added some earrings.

Now try your own version of this portrait. Think about each part of the face and how you can change things in ways that are true to your style.

Fill this space with as many ways to draw an eye that you can think of. Try some realistic and graphic versions.

Now, draw all types of different noses.

Cover this section in mouths. Try some closed, smiling and sad mouths.

Finally, pick your favourite drawings from each section and create a face!

Let's draw some more portraits. Here's another reference photo for you to work from. If you need a refresher, check out the Interpreting Reference lesson on page 116 and also all of the facial features you drew on page 118. Keep in mind that you can make this portrait as realistic or cartoon-y as you'd like. You can also change the colours and add patterns.

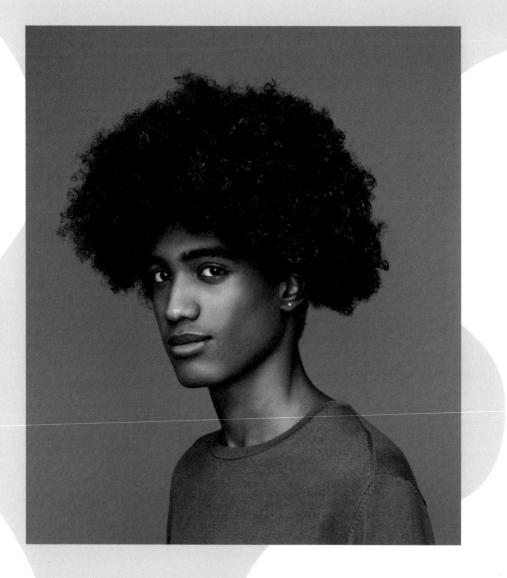

Time for another portrait! Draw your version of this reference photo on the next page. Really think about how you can make it your own. If you need a refresher, check out the Interpreting Reference lesson on page 116 and also all of the facial features you created on page 118.

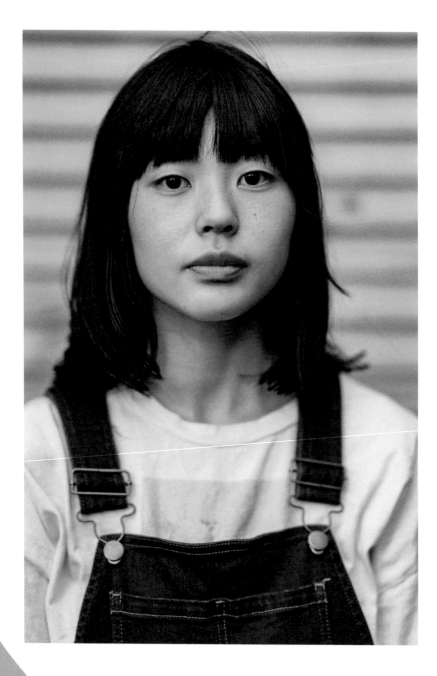

Using the building below as reference, create your own drawing on the next page.

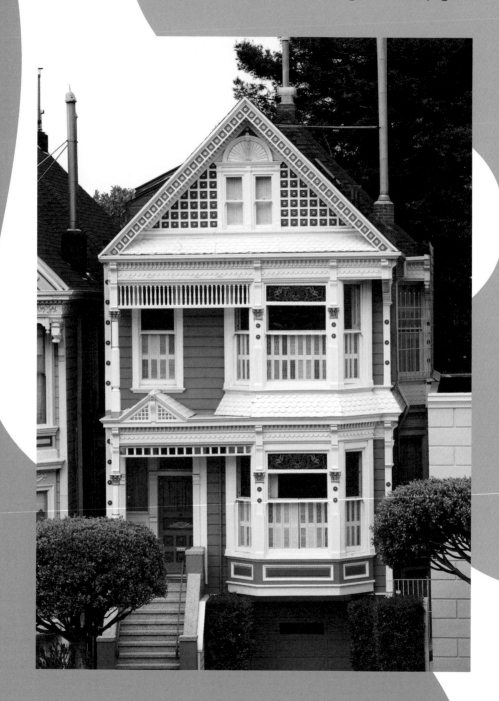

Use the landscape below as inspiration for your own drawing. If you are a little rusty on perspective, flip back to the lesson on page 94.

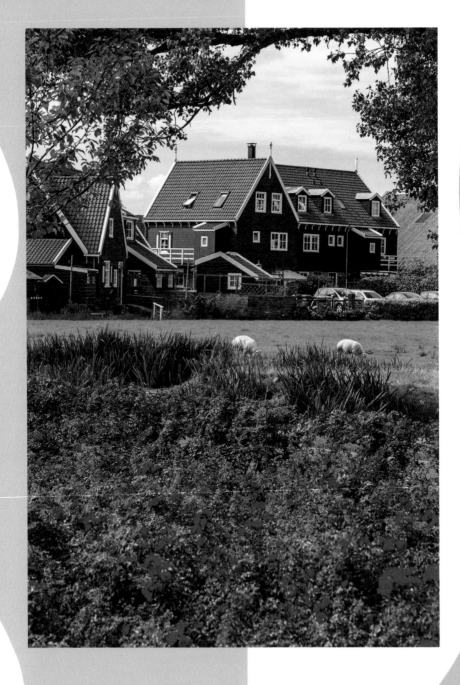

Use this plant as inspiration to create your own botanical creation. Maybe it has purple or polka-dot leaves? Also, feel free to draw any patterns you'd like on the pot.

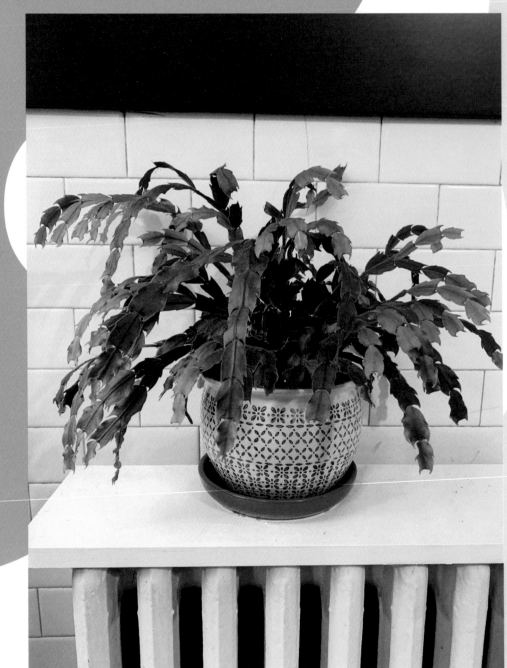

Let's draw a still life! Create a drawing inspired by the objects I arranged below. You can be as realistic or as abstract as you'd like. Don't think you need to copy it exactly to be successful.

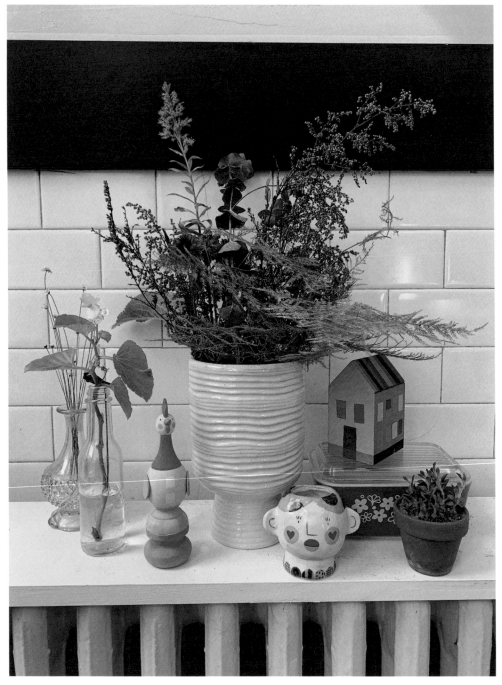

Lesson:

FIGURE DRAWING WITH SHAPE

Figure drawing is a fun challenge! There can be a lot of math-y, proportion-based ways of drawing people, but I was never really drawn to them. In this lesson, we'll talk about breaking the figure down into basic shapes.

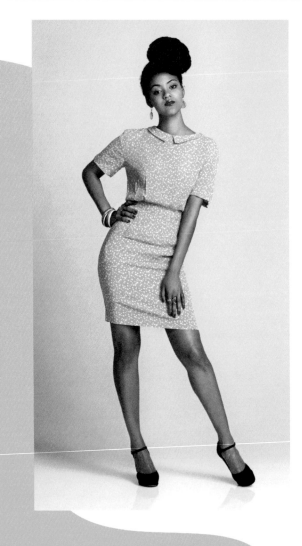

Before starting to draw, it's really important for you to really study your reference, whether you are drawing from life, drawing from your own photo or drawing from someone else's photo.

Before jumping into drawing, I take in the gesture of the pose first. You can see that in this pose, the woman is holding her body at different angles, which is why I thought it would be an interesting pose to draw. Her head is titled to the left, then her torso to the right, and she is holding her weight on her left foot, causing her left hip to jut out.

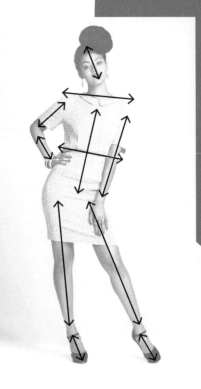

Here is a visualisation of the different angles I was talking about. They will be a really helpful guide for when we start drawing our shapes. Having the angles correct (or even exaggerated a bit more) really helps capture the essence of the pose.

We'll start with the head first. I see everything as an oval, from her hair, to her head, to her ears. Remember to mind those angles.

Now let's move on to the torso. It looks like a trapezoid. Once I drew the torso, I added in the neck. Because her head is at an angle, the left side of her neck is shortened and the right side is longer.

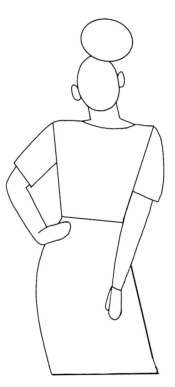

The sleeves and skirt are somewhat rectangular with some curves. You can start by drawing a rectangle and then adding curves.

The right arm is a rectangle that tapers as it nears the hand. The left arm is a bit trickier, but look at the shape of the upper arm and lower arm and draw what you see. For hands, we will do a simple mitten shape.

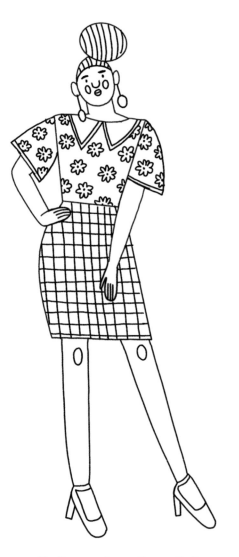

Now for the legs and feet! I like to keep them both pretty simple. The legs will just be two lines that follow the angles in the reference. For the feet, I like to draw a wedge shape.

Finally, my favourite part! Once the basics are down, I dive into the details. I decided to make the sleeves and collar much larger, to add heels to the shoes and add pattern throughout.

It's your turn! Draw the woman using shapes then add your own finishing details.

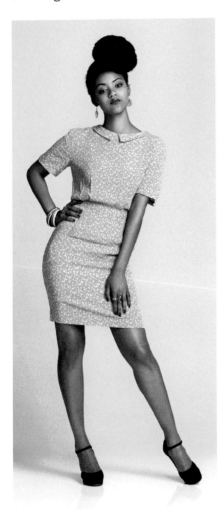

Let's draw another figure. In this reference, the shapes jumbled below are what I see.

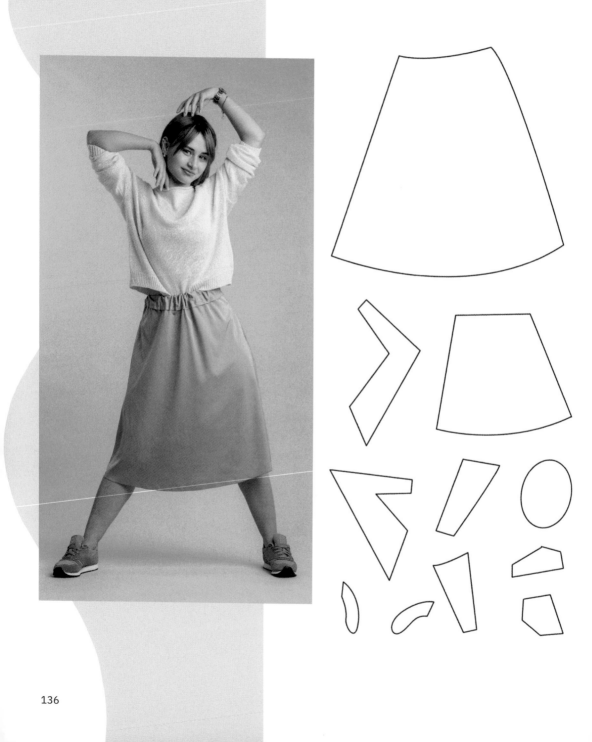

Use the shapes to guide your figure drawing on this page.

Find a reference of a person and draw it here. Don't forget to make it your own!

Find another reference photo of a person and draw it on this page.

Now it's your chance to create your own reference. Pose or have a friend pose in a position you'd like to draw. Take a photograph and then interpret that photo here.

Take another reference photo of your own and draw it here. This time, try to change the clothes the person is wearing. Add your own colours and patterns everywhere!

Have a friend pose and draw them from life. If you want to loosen up a bit, try doing a blind contour or a very quick sketch of the pose first.

Use this page to make a more finished drawing of your friend.

Lesson:
FINDING INSPIRATION

Finding inspiration and figuring out what to draw can be tough. Let's talk about where I turn when I'm stumped.

Online

The internet can be an awesome and sometimes overwhelming place to find inspiration or reference. There is just so much out there!

My favourite place to look is Pinterest. I love to browse through photos of colourful interiors, fashion and quilts.

Museums

Spending an afternoon at a museum is a great way to refresh and get ideas. You can be inspired by colour palettes, small portions of a painting or even the patrons and architecture of the museum. It also can be fun to draw directly from paintings or statues at the museum. There is a lot to learn from the masters.

It doesn't have to be an art museum either. It is also tons of fun to draw at natural history museums, zoos, aquariums, botancial gardens, etc.

Travel

Travel, both locally and far away, is probably my favourite way to find inspiration. I love taking walks and snapping photos of houses, buildings and flowers. The same applies to when I'm travelling a distance! I love seeing new things, whether that be architecture, tiles, wallpaper, packaging, etc., and finding ways to interpret it in my own way and incorporate it in my work.

These are also photos that I catalog and reference when I need some ideas. They really come in handy!

Libraries

Libraries are another amazing place to look for inspiration. I rent out or look through art books and take photos of what I enjoy. Then I take those photos, organise them in my own personal files and go back to them when I'm looking for ideas. In addition to art books, children's books are another great way to see interesting techniques and stylisation.

Past Work

This might sound a bit weird, but sometimes I will flip through my old sketchbooks or Instagram if I don't know what to draw. Something small might catch my eye, like a flower, a portrait or pattern that I decide would be fun to reimagine into something new and exciting.

145

Virtual Tour List

Virtual museums became a great resource for me during the thick of the pandemic. It was easy to feel stale and uninspired creatively when there was no way to travel or go to museums. When I was teaching a sketchbook class, I thought about how my students could have a museum experience at home. To my delight, there many virtual tours or collection photos available at museums all over the world.

The Frick Collection
New York, USA

This museum is the collection of Henry Frick and features mostly European art, furniture, rugs and porcelain.

The Art Institute of Chicago
Chicago, USA

One of the oldest and largest museums in the US. They have curated art from all over the world, from ancient to modern times, including Africa, the Americas, Asia and Europe.

National Museum of Natural History
Washington DC, USA

The museum's collection contains over 145 million specimens, which is the largest natural history collection in the world.

Victoria and Albert Museum
London, England

This is one of my favourite museums I've ever been to. The V&A is the world's largest museum of decorative and applied arts. They have clothing, furniture, ceramics, textiles, prints, drawings and photographs.

National Portrait Gallery
London, England

An art gallery in London featuring portraits from throughout British history.

Google Arts and Culture

A collection of great images and videos of artwork from museums all over the world.

Louvre Museum
Paris, France

The largest art museum in the world, it's home to some of the best-known works of art, such as the Mona Lisa.

MMCA
Gwacheon-si, South Korea

There are four branches of the museum and they all highlight different modern and contemporary art from Korea and the world.

Tokyo National Museum
Taito City, Japan

Artwork and antiquities from Japan and throughout Asia.

Virtually visit a museum from the list and draw one of the favourite things you see here.

Virtually visit another museum. This time, instead of directly documenting something you see in the museum, use a painting, sculpture or object as inspiration to create a drawing.

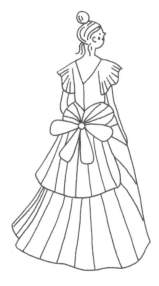

Lesson:
DRAWING AT HOME

Finding inspiration and figuring out what to draw can be tough. Let's talk about where I turn when I'm stumped.

Drawing is a great thing to do, but sometimes it can be hard to figure out what would be interesting to sketch. Thankfully, there's plenty you can do at home to practice your skills. Even mundane items can be drawn beautifully and can help develop your skills. Some of these ideas we will explore together in the book, but others can be for ideas when you are working on your own in the future.

Objects

Household
Draw your favourite knick-knack
Set up objects in a still life and draw
Sketch your indoor plants
Draw your outdoor plants
Draw a lamp in your house
Draw a pattern in your house
Draw your favourite piece of furniture
Sketch your car or bicycle
Draw a lit candle
Draw a watering can
Draw a pair of scissors
Draw the taps of your sink or bath

Food
Sketch what is in your fruit bowl
Cut a fruit or vegetable in half and draw
Draw a liquid in a glass
Draw pots and pans
Draw food packaging
Draw your favourite food in your fridge
Draw your cutlery
Draw an open kitchen cabinet

Clothing/Accessories
Draw your jewellery
Draw a pile of clothes
Draw your favourite pair of shoes
Draw a pair of shoes with laces
Fold up a belt and draw
Draw a baseball cap or other hat
Sketch a pair of novelty socks
Draw the texture of a thick sweater
Draw your watch
Fold up a scarf and draw it
Draw your dress shoes/heels
Draw a patterned item of clothing

Hobbies
Draw your art supplies
Draw a stack of books
Draw the book you are reading
Sketch your favourite record cover
Draw your sewing machine
Draw knitting needles or a crochet hook
Draw a box of pins
Sketch a tennis racket
Redo a drawing you did a while ago
Draw pieces from a board game

People/Animals

Draw your partner, roommate or child
Draw your pet
Draw a self portrait in the mirror
Draw your hands and feet
Do blind contours of yourself
Do blind contours of any roommates/pets
Draw yourself in your favourite outfit
Take reference photos of yourself
Sketch from your favourite family photo
Draw birds, squirrels, etc. in your yard

Interactive

Draw while listening to music
Draw while watching TV or a movie
Do a collaborative drawing with a friend
Draw while someone cooks a meal
Draw your morning routine
Draw your entire day
Draw what you snacked on that day
Draw self portraits throughout the day

Exteriors/Interiors

Draw your kitchen
Draw your bedroom
Draw your living room
Draw your dining room
Draw a piece of furniture in perspective
Draw the view out of your window
Draw the exterior of your house
Draw your neighbour's house
Draw the trees in your yard/on your street
Draw a telephone pole
Draw a very messy room before you clean it
Draw the top of your desk (clean or messy)

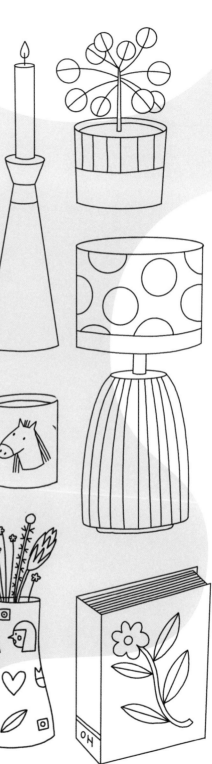

Cover this spread in drawings of your own shoes. Use as many different media as you can.

Draw all of your houseplants on these pages. If you don't own any plants, you can look some up online.

Sketch while watching your favourite TV show or movie. You can draw the characters or write out what they are saying.

Try setting up your own still life with some of your favourite objects from your home. To warm up, do a blind contour of your still life on this page.

Now that you are warmed up, draw a more finished version of your still life here.

Draw your pet. If you don't have a pet, you can draw my dog, Sukie.

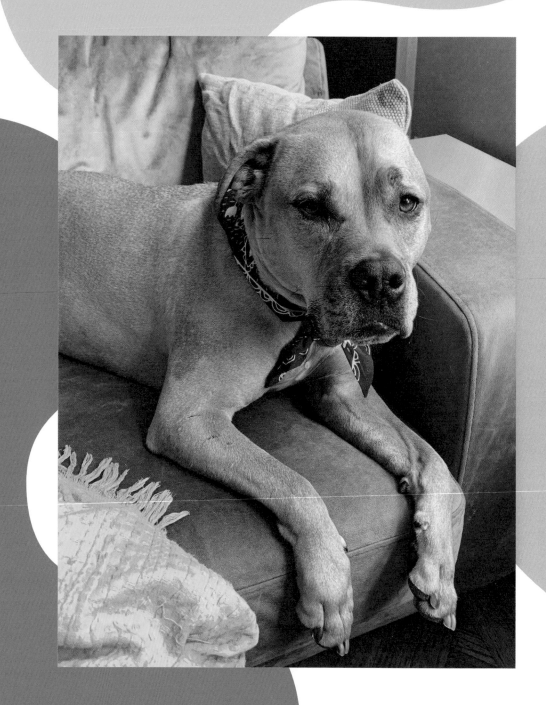

Go back to the Drawing at Home lesson on page 150. Pick a prompt from the list and draw it here.

Choose another prompt from the Drawing at Home lesson on page 150 and draw it here.

Lesson:
DRAWING ON THE GO

Drawing on the go is a great challenge, but it's also super fun! Let's chat about some techniques for drawing away from your desk.

Preparation

The first order of business is to prep your tools for drawing on location. If you are bringing this book with you, I suggest packing pencils, coloured pencils, paint pens and/or gel pens. Sometimes, I like to take tons of colours. Other times, I intentionally limit my colour palette and only take a few colours along. It's really helpful to have a small bag that you put drawing media, an eraser and a handheld pencil sharpener in.

If you are drawing in a separate sketchbook, you could bring wetter media like paint and water brushes (these are so cool). Also, when I am working in my sketchbooks, I typically paint the background of the pages at home. That way I can draw on top with paint pens, gel pens and coloured pencils. This results in a more finished looking drawing/painting, but I was able to bring relatively mess-free materials.

Location

Drawing on location is the perfect next step in your drawing practice. So far, most of the things we have been drawing are stationary and not moving. A good way to get used to drawing out of your home is to first draw subjects that won't walk away as you are drawing them!

To warm up, I suggest doing some blind contour drawings first. If you need a reminder on what those are, check out the lesson on page 38. Once you feel ready to go, try drawing some objects that you find interesting. If you are in a cafe, maybe there is a cool chair or clock to draw. A museum might have a beautiful statue for you to interpret. If you are at the park, you could draw trees, benches, flowers, light posts or even parked cars.

Once you are feeling confident with that, I suggest challenging yourself to draw snippets of fuller scenes you see both indoors and outdoors. You can even try drawing them in perspective.

People

Drawing anything moving is always going to be a bit more challenging. It can understandably be frustrating to be drawing someone's face and, as soon as you are about to finish, they move! Honestly, I look at it as part of the fun and use it as encouragement to draw as quickly as possible.

For people, I again suggest starting out with blind contour as a warm up. Then you can move to just drawing faces, shoes, etc. and work yourself up to drawing a full figure. I always try to look for people sitting who look like they might be there a while, i.e. if they are eating lunch or reading.

167

It's your turn to draw on the go. Do some blind contour drawings on location.

Now that you are warmed up, try drawing some objects (like chairs, trees, planters, etc.) on this page.

Draw people while out on location. You can draw portraits on their full figure.

Take your book to a park and draw what you see. If you want to challenge yourself, you can draw moving things, like people or animals. You can also draw things that stay still, like lamp posts, flowers and trees.

Take your book to a cafe next. At a cafe, you can draw people working, chatting and sipping their tea. You can also draw the room and tables as a perspective-drawing exercise. Feel free to draw one large scene or little snippets of what you see.

A museum is a great place to take your sketchbook. You can be inspired by the art/collections or draw the patrons! If you aren't able to access a museum, check back to page 146 for the virtual museum list.

It can also be great to take your own reference photos of things you see out and about. Drawing on location isn't always possible, so you can use your photos later when you are at home. I always take photos when I travel then make an inspiration catalog on my computer. Spend some time taking photos of something you find inspirational and use these pages to draw from your photos.

Lesson:
FINDING YOUR STYLE

Developing your style is a life long journey! Here are some tips on how to keep building your visual language.

Find Your Inspiration

It's so important to find work that you love and that inspire you to make art. I'm constantly finding new things. For example, over the past year, I've become really interested in looking at and making quilts. My love of quilting has seeped into my artwork. It's so cool that things you do outside of drawing can come back and inform your artwork. Think about how you can relate activities you love back into your drawings.

Also, find artists from the past and present that you admire. They don't have to be illustrators or painters: they can be textile designers, photographers, fashion designers. Find work that resonates with and inspires you.

Experiment

Experimenting is one of the most important pieces of the puzzle when it comes to finding your style. It's so important to attempt new things, push yourself and not allow yourself to be intimidated. Try a new colour palette! Try drawing a new subject! Try all sorts of new media and materials! Experimenting helps to keep your work fresh. You won't find new things you like if you never give them a try.

Keep Making Work

Like most things, the more you practice, the better you will get, but it's very important to find a balance. You don't need to be constantly churning out work and pushing yourself too hard. Burn out is real! Instead, think about how to realistically motivate yourself and how much time you can spend on your artwork each week or month. Maybe you want to spend a half hour drawing every day or make one piece a month. Find a goal that works for you and keep practicing.

It's a Journey

Finding your style really is a journey. There isn't really a cookie-cutter solution to finding your creative voice. It just takes a lot of time and a lot of practice to get there.

Style is also a constantly evolving thing. As you change, your style or the things you are interested in drawing may change with it. Even as a professional artist, I notice a lot of subtle changes when I look at my work from a few months or years ago.

Keep my suggestions in mind as you continue your path in art. Find want you love to look at, what you enjoy making, try new things and keep drawing!

Remember your Fun Things to Draw List way back on page 19? Let's revisit it! Spend some time filling it out if you previously left it blank. Once you have it completed, draw a few of your favourite things on these pages.

Fill another spread with drawings inspired by your Fun Things to Draw List on page 19.

Draw something, in your own style, inspired by your favourite piece of artwork.

On this page, sketch something inspired by one of your favourite hobbies.

Last exercise! Try a new material or try drawing a new subject on these pages.

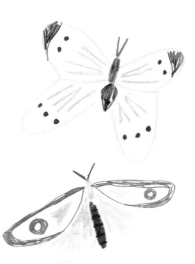

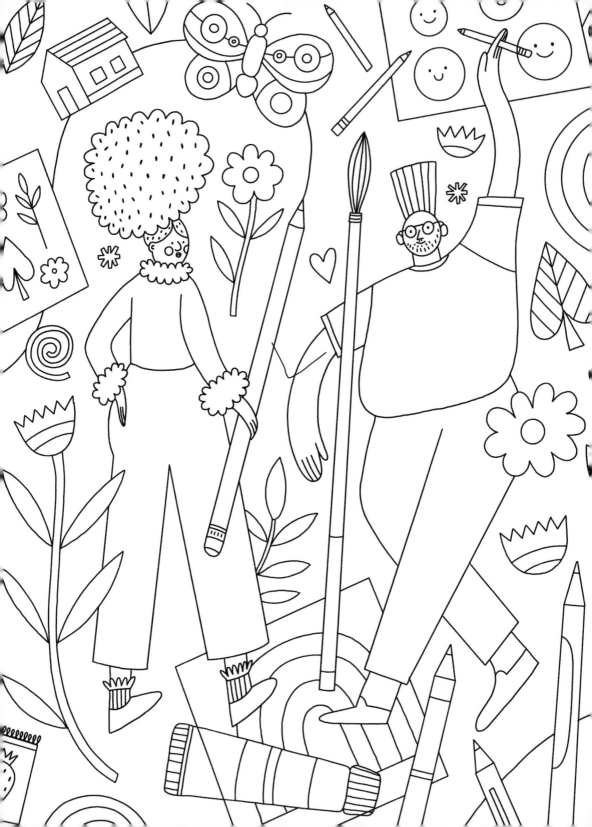

Bye for Now

You've made it to the end of *Sketch Like No One is Watching*! Sketchbooks are my favourite thing to draw in, and I hope through this book you have also discovered the magic of them.

Remember, whether you are drawing as a hobby or as a career, we are all constantly learning, changing and getting better. Instead of getting bogged down in your mistakes, or giving up when you find something challenging, keep trying! The more you practice, the more you will continue to improve.

I hope this book helped you find some subjects that you really enjoy drawing. As you keep sketching outside of this book, keep in mind what you loved working on and continue that in your own sketchbooks. If you need a refresher on a lesson, grab this book.

Most of all, keep experimenting, creating, and drawing! I can't wait to see what you make.

Acknowledgments

I'm so thankful to have a lot of lovely people in my life who motivate and support me. I'm especially grateful for my amazing partner, Matt. He helped me brainstorm, checked my drafts and was so encouraging throughout the process.

Another thank you to my wonderful editors, Matt Tomlinson and Kate Pollard, for being inspiring and lovely people to collaborate with.

Published in 2022 by OH Editions,
an imprint of Welbeck Non-Fiction Ltd,
part of the Welbeck Publishing Group.
Offices in London, 20 Mortimer Street, London, W1T 3JW,
and Sydney, 205 Commonwealth Street, Surry Hills, 2010.
www.welbeckpublishing.com

Design © 2023 OH Editions
Text © 2023 Molly Egan
Illustrations © 2023 Molly Egan
Photograph credits: all photographs © 2023 Molly Egan except for:
page 116 © iStock.com/max-kegfire
page 120 © iStock.com/ CoffeeAndMilk
page 122 © iStock.com/recep-bg
page 124 © iStock.com/Jose Girarte
page 126 © iStock.com/SAKhanPhotography
page 132 and 135 © iStock.com/PeopleImages
page 136 © iStock.com/photographer

A CIP catalogue record for this book is available from the British Library.

ISBN 978-1-80453-043-6

Publisher: Kate Pollard
Editor: Matt Tomlinson
Text and illustrations: Molly Egan
Production controller: Arlene Lestrade
Printed and bound by Leo Paper Products Ltd

FSC
www.fsc.org

MIX
Paper | Supporting
responsible forestry
FSC® C020056

10 9 8 7 6 5 4 3 2 1